Let's Draw!
Cute and Easy Images

indilop@vistacolorspublishing.com
All Rights Reserved 2024

Thank You for Choosing us

We will Appreciate your Feedback on Amazon

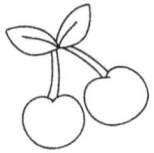 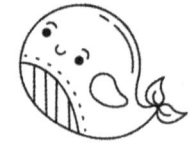

This Book Belongs To

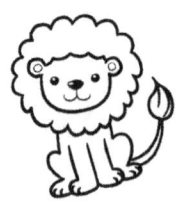 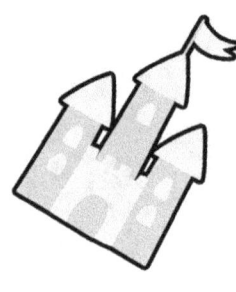

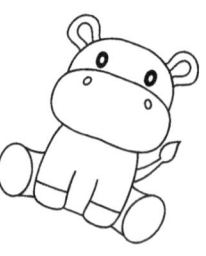

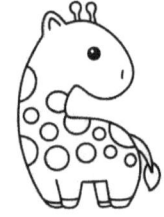 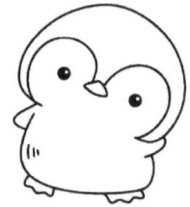

How to use this book

To get started, gather a pencil and an eraser. Feel free to use pens, markers, or any other drawing tool you prefer.

Begin by lightly sketching, allowing for easy erasing in case of mistakes.

Progress by following the step-by-step instructions indicated by the arrows.

If you find yourself struggling, reference the final drawing for guidance.

Once you've finished your drawing, feel free to add color however desired.

Whale

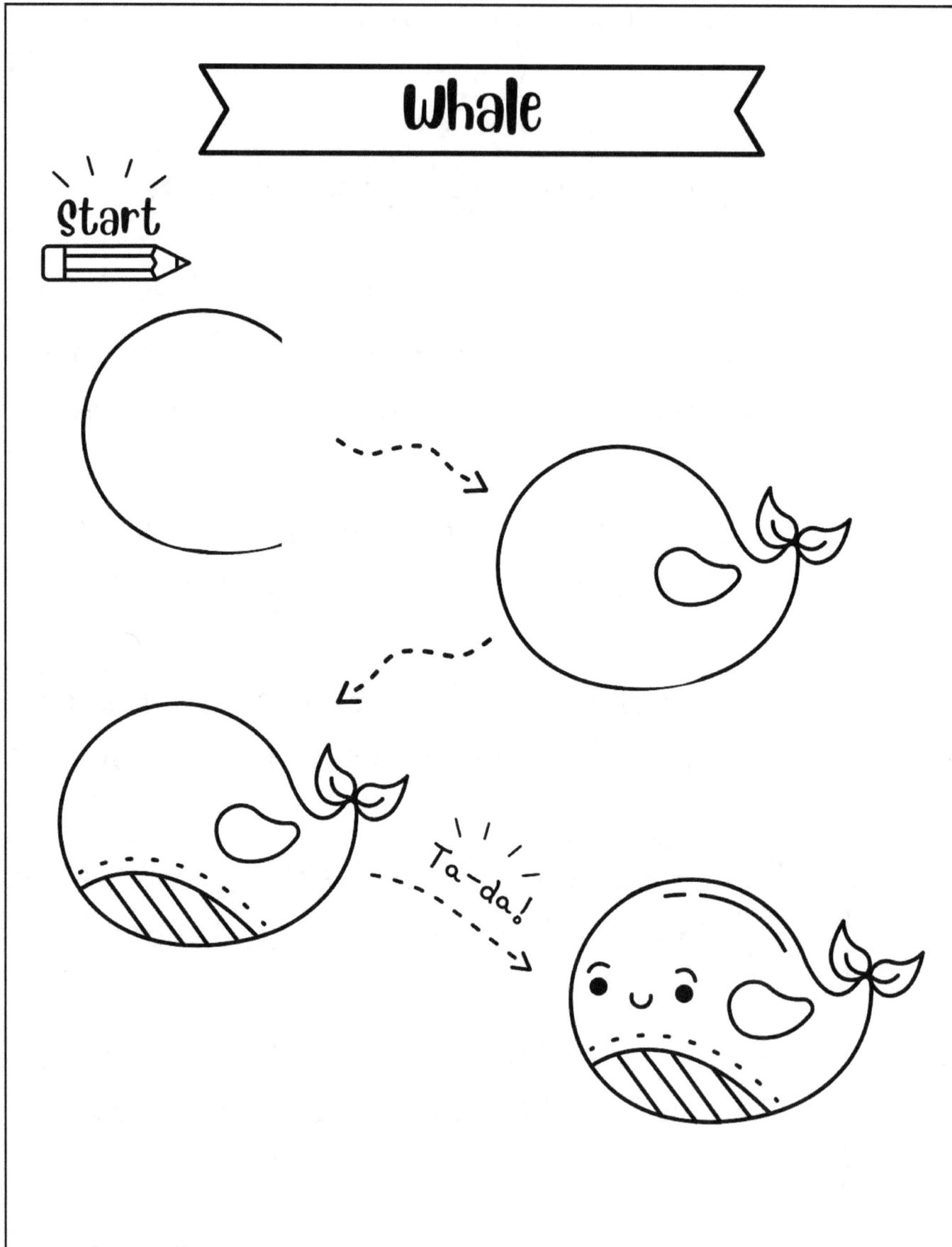

Milk tea

Start

Ta-da!

Your Drawing

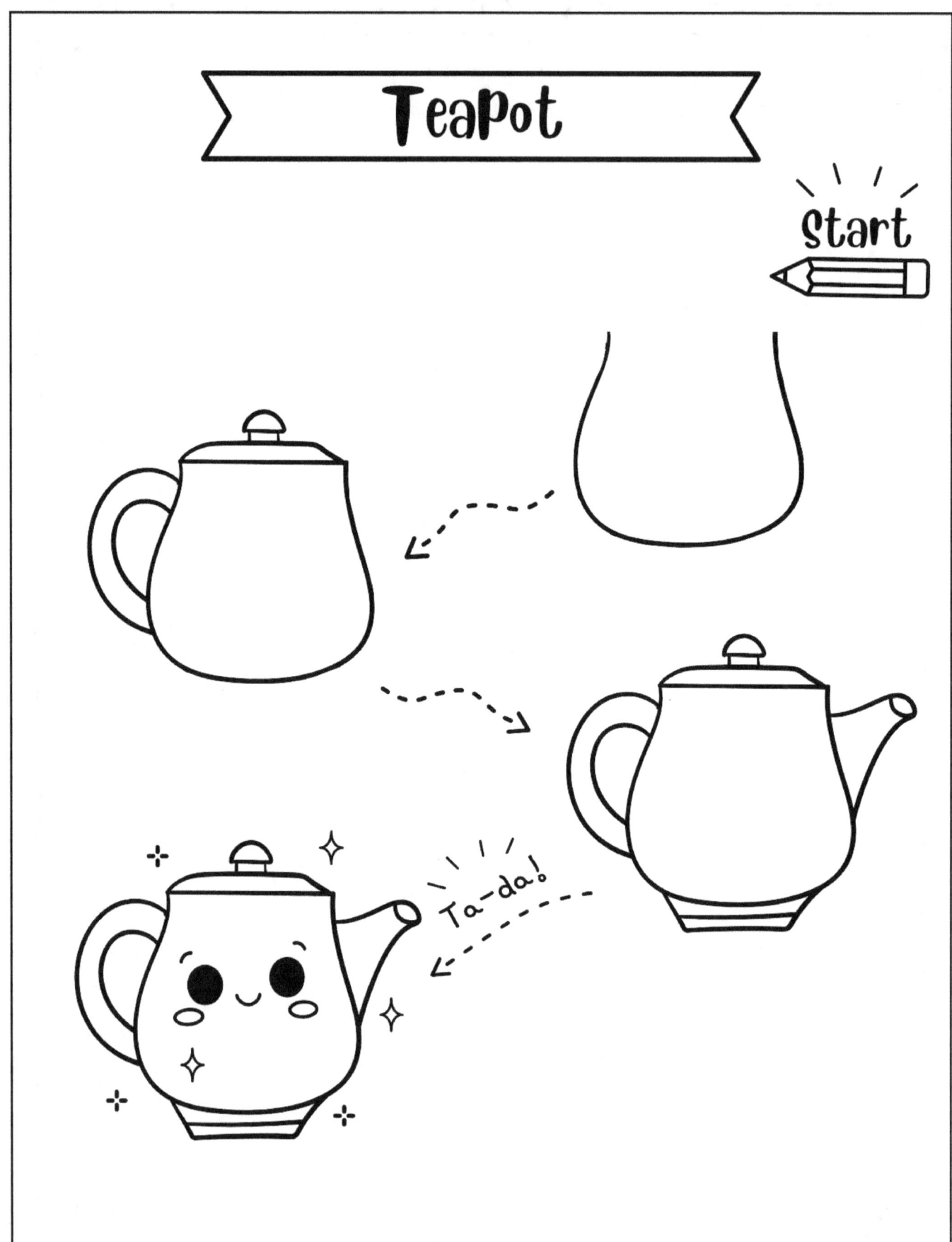

Fish

Start

Ta-da!

Your Drawing

Boat

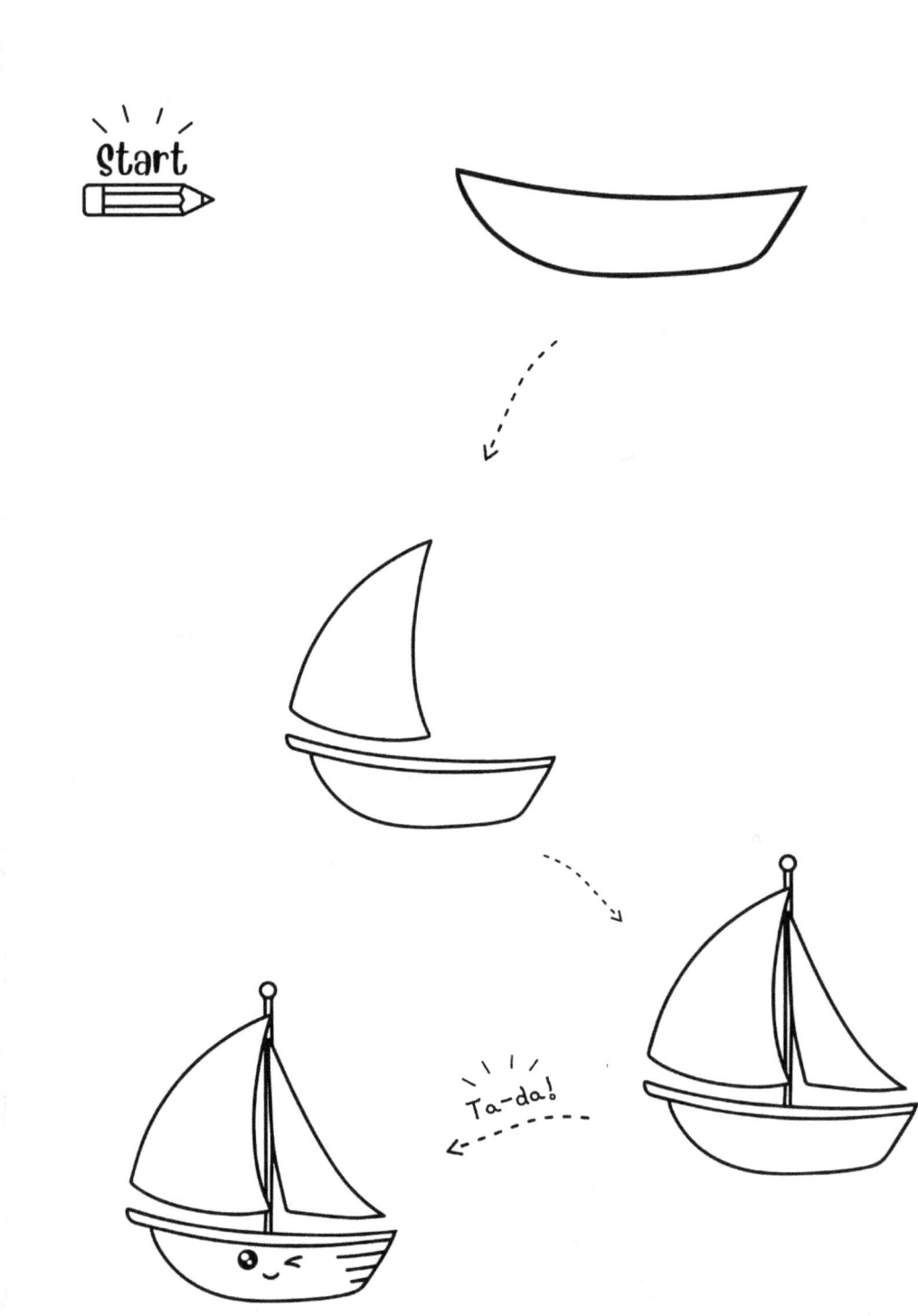

Mushrom

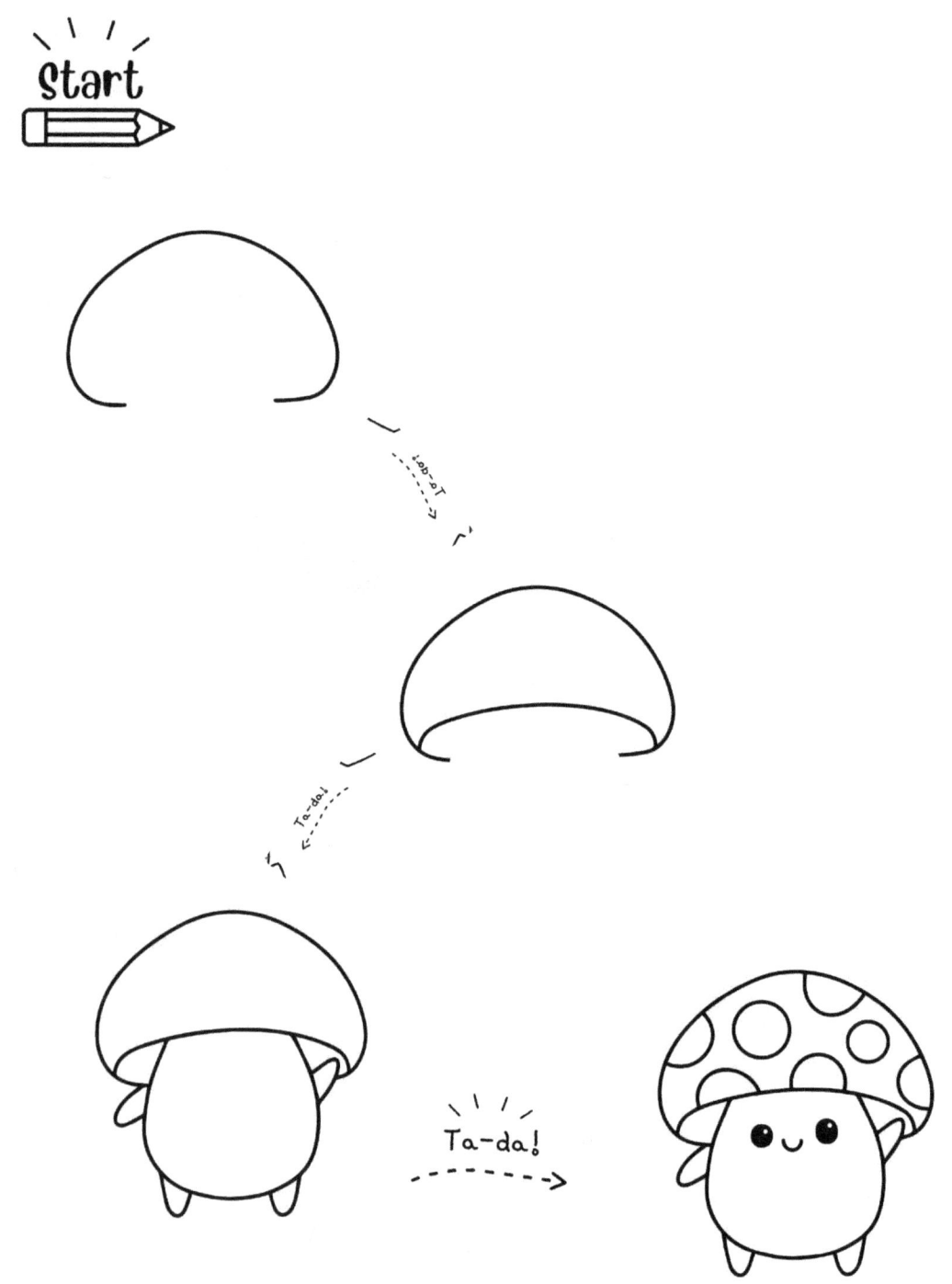

Your Drawing

Penguin

Start

Ta-da!

Your Drawing

Pot

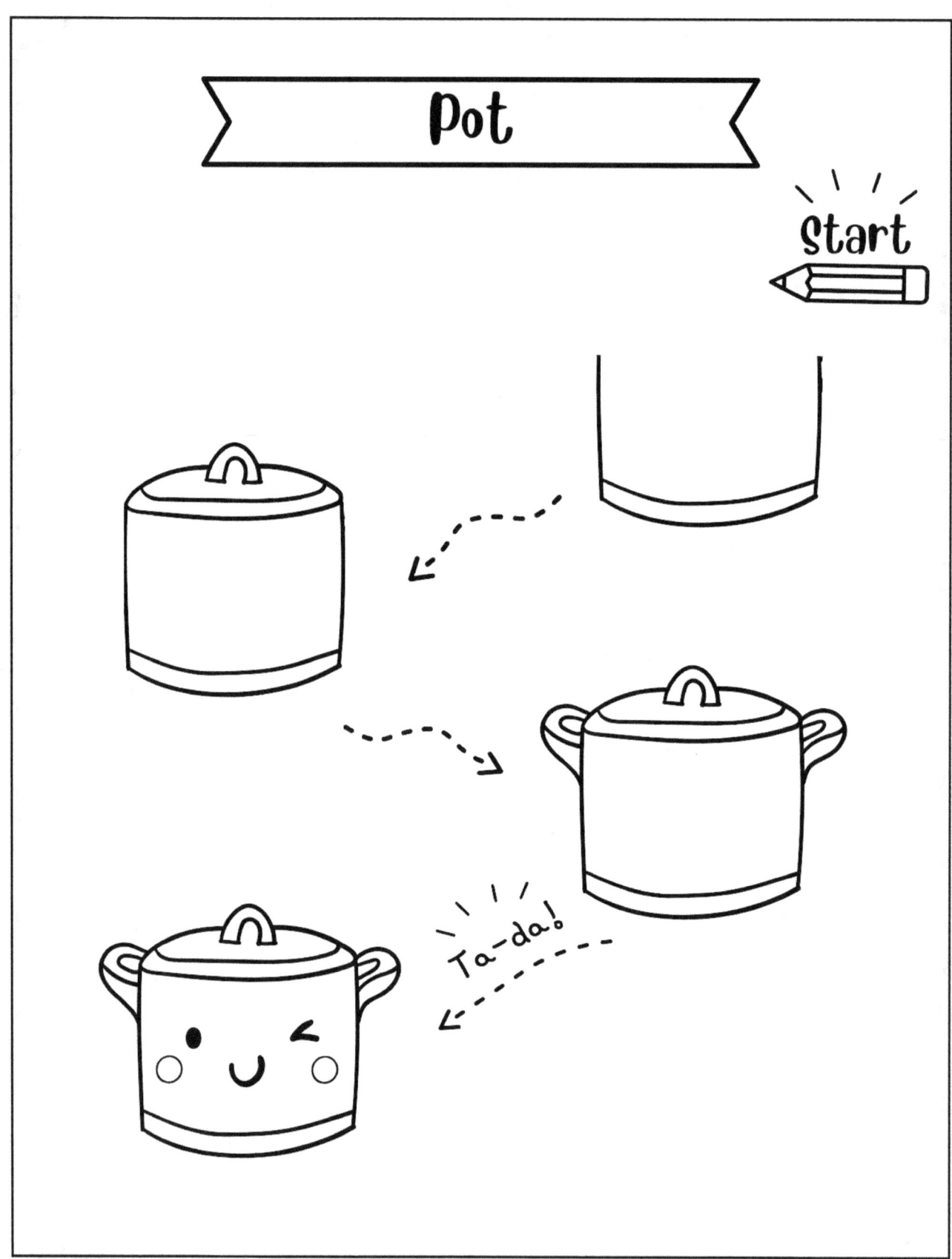

Your Drawing

Boat

Start

Ta-da!

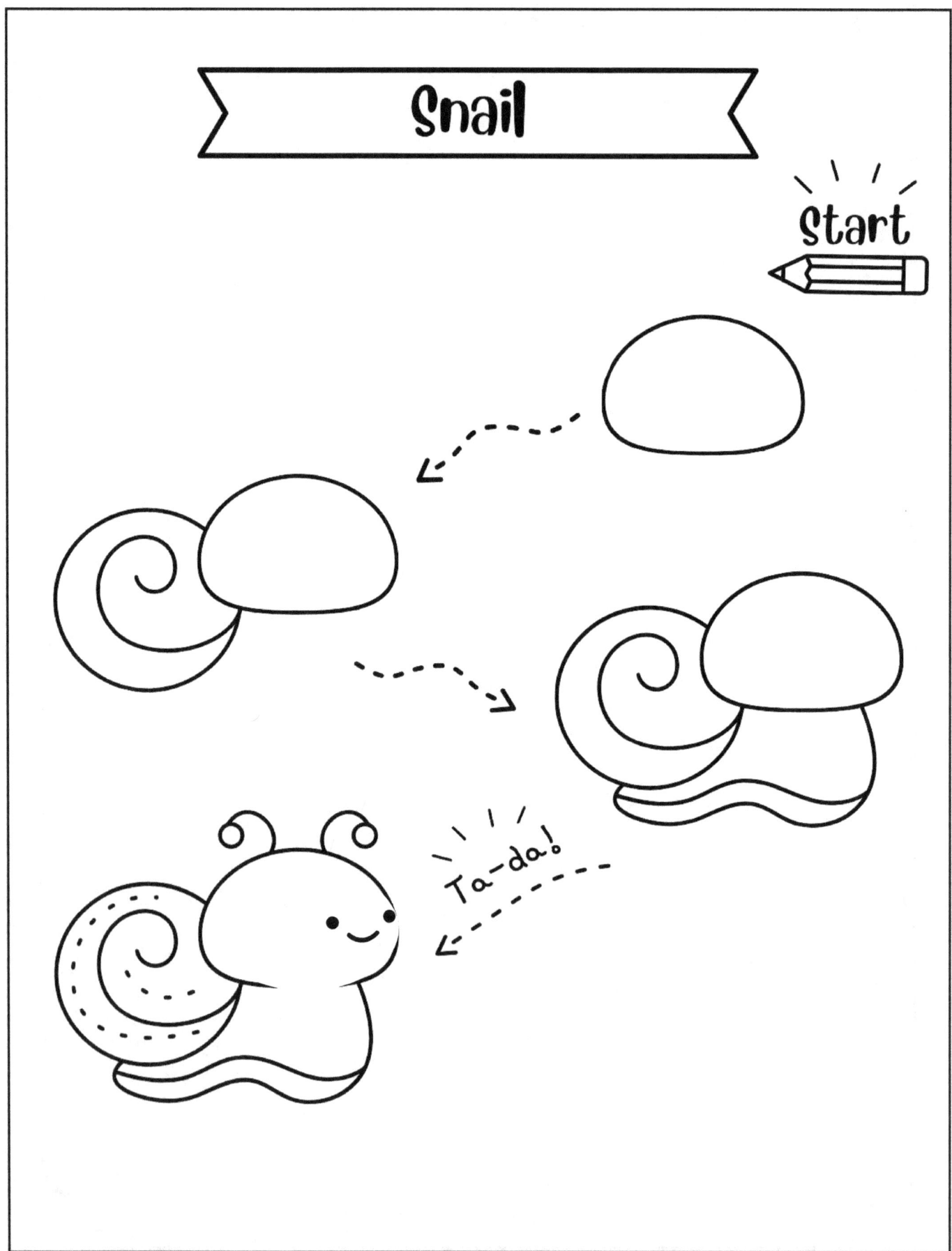

Your Drawing

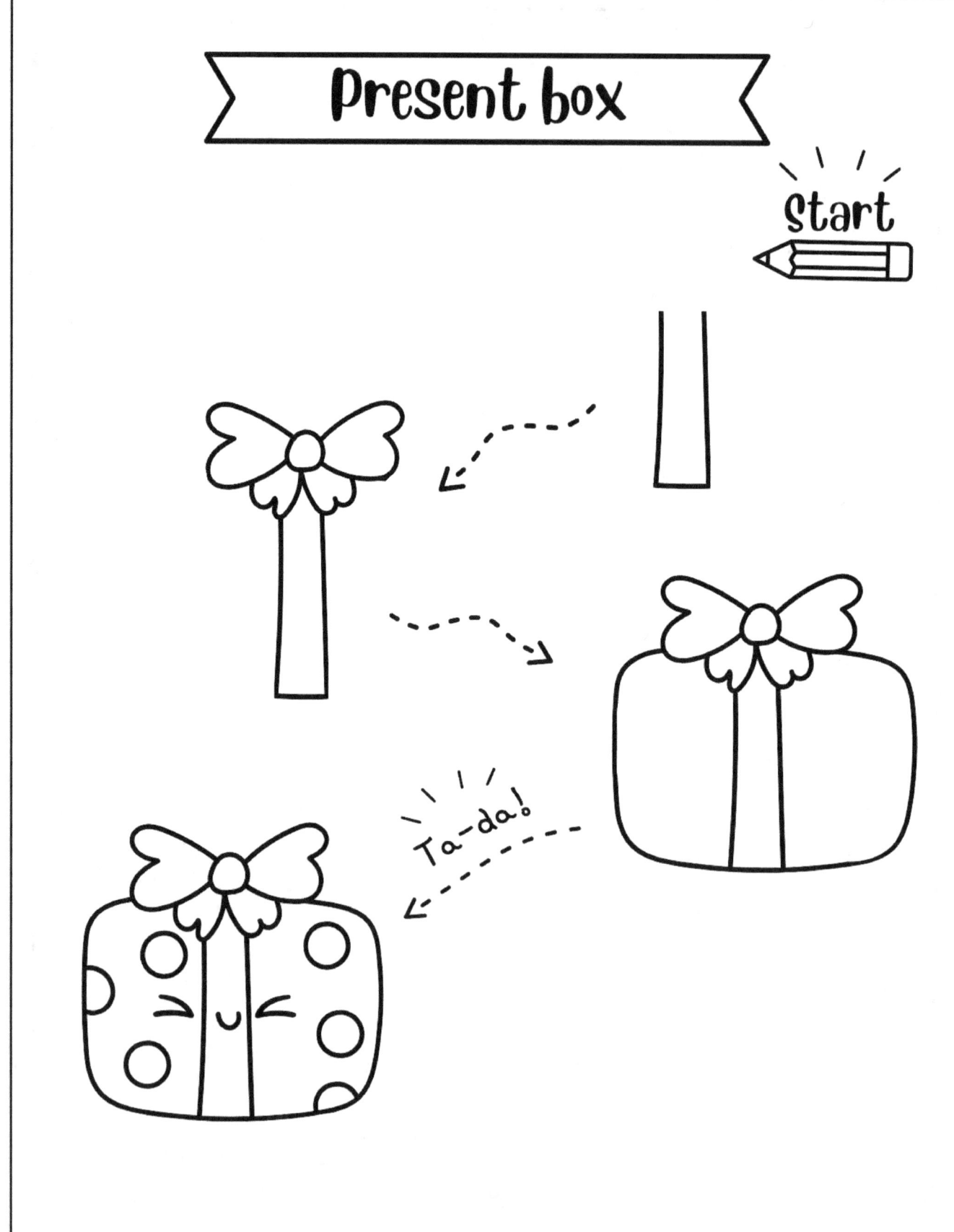

Santa

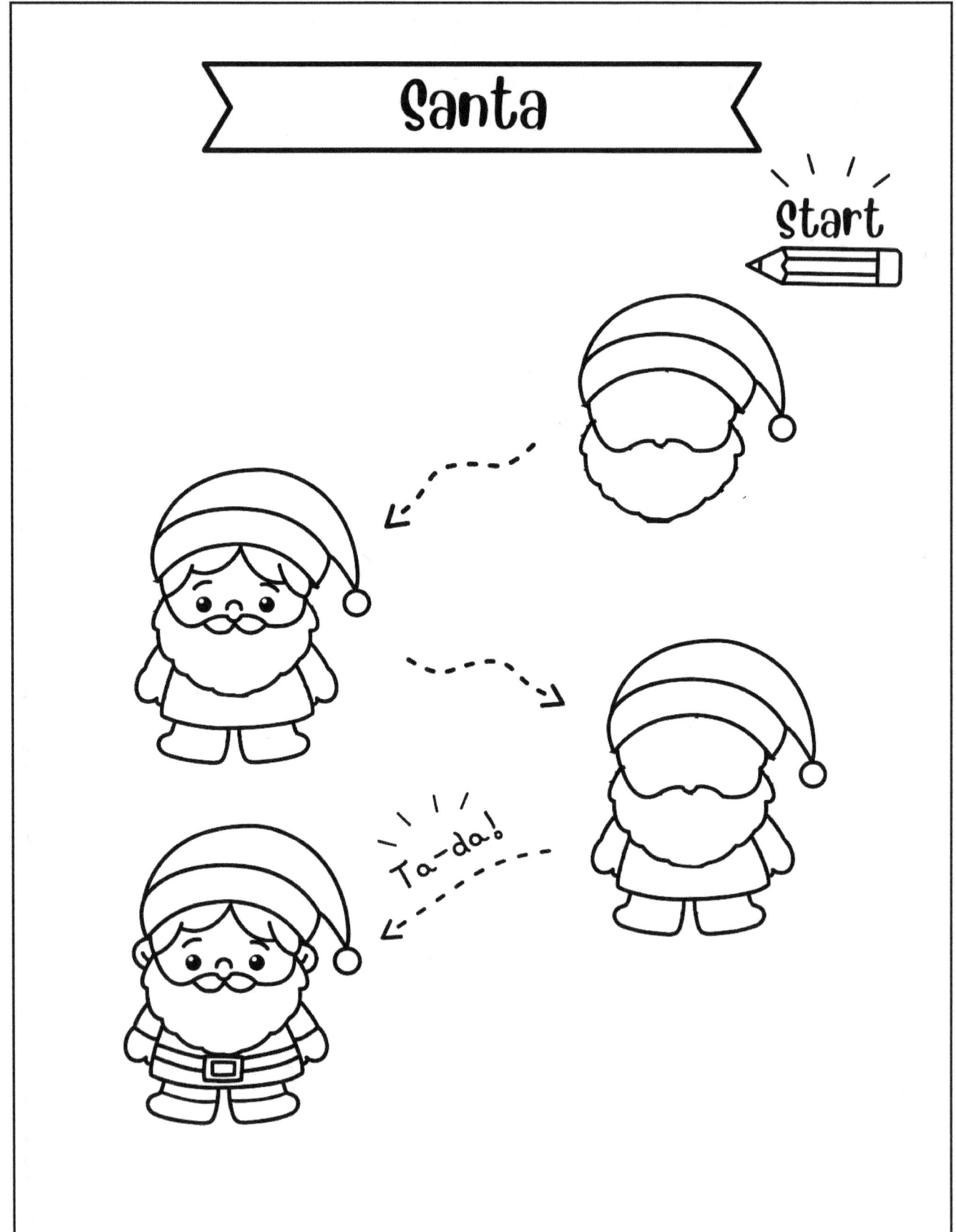

Your Drawing

Cactus

Start

Ta-da!

Your Drawing

Giraffe

Start

Ta-da!

Llama

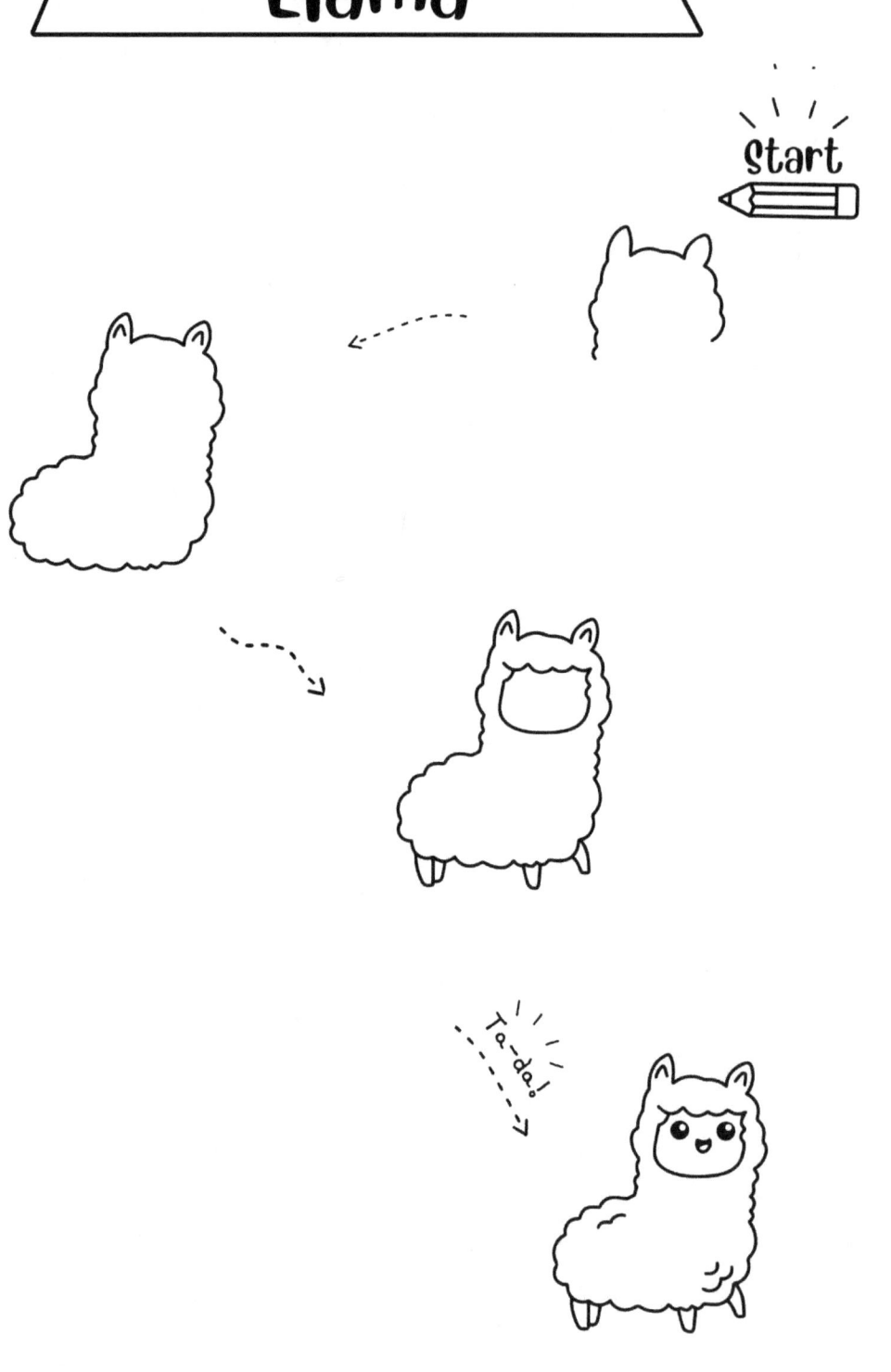

Clock

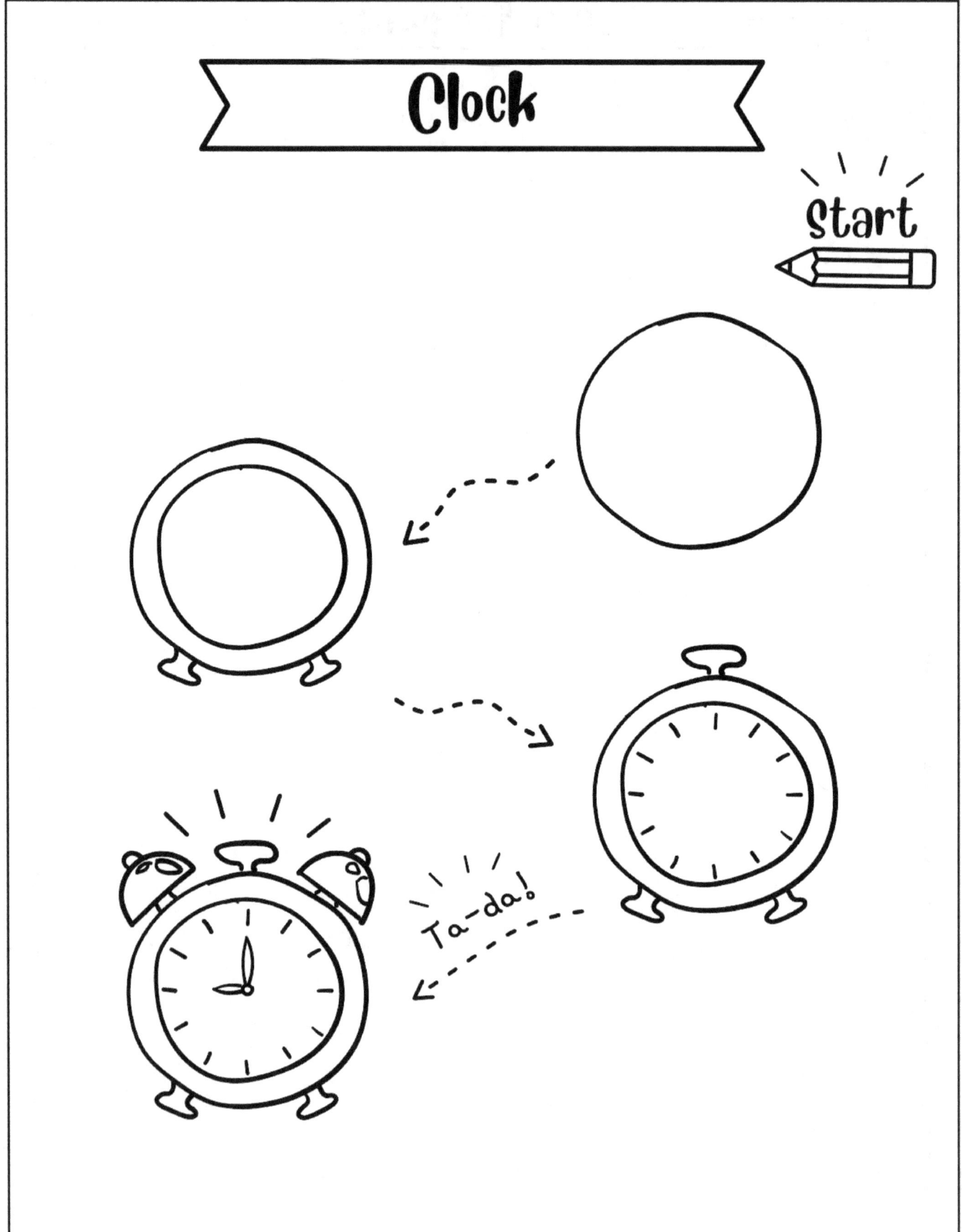

Your Drawing

Lion

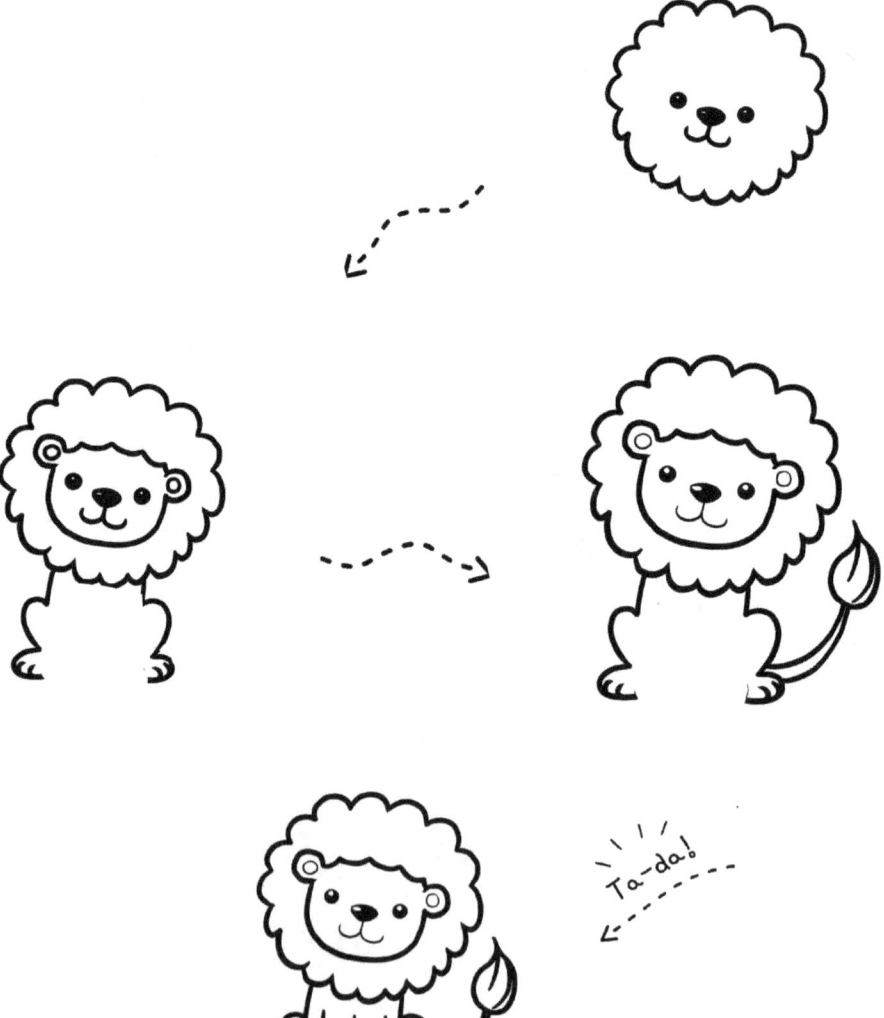

Spider

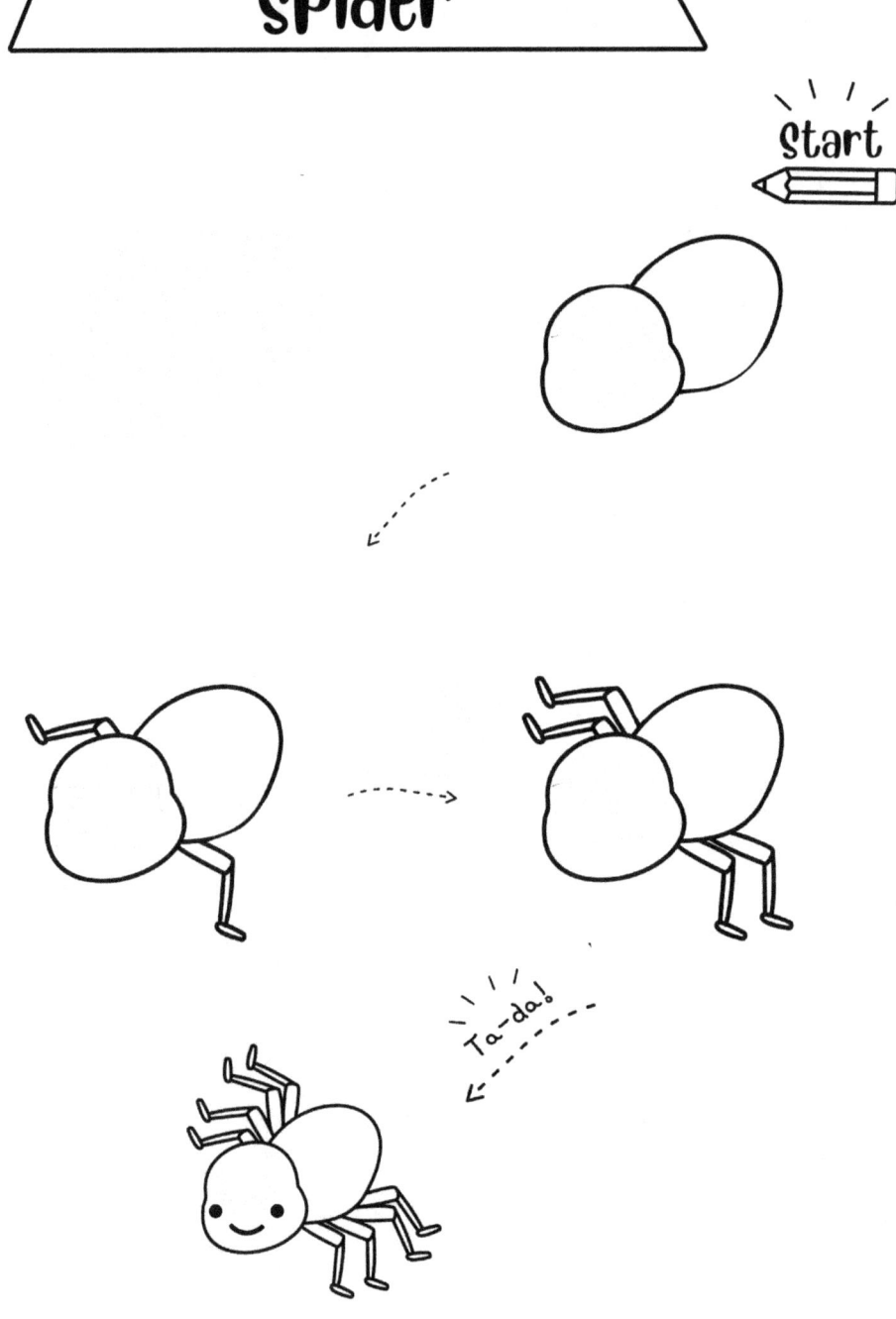

Your Drawing

Hippo

Start

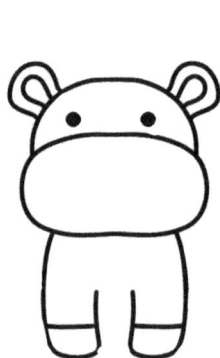

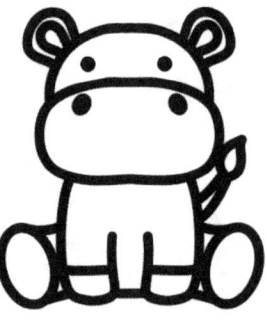

Ta-da!

Your Drawing

House

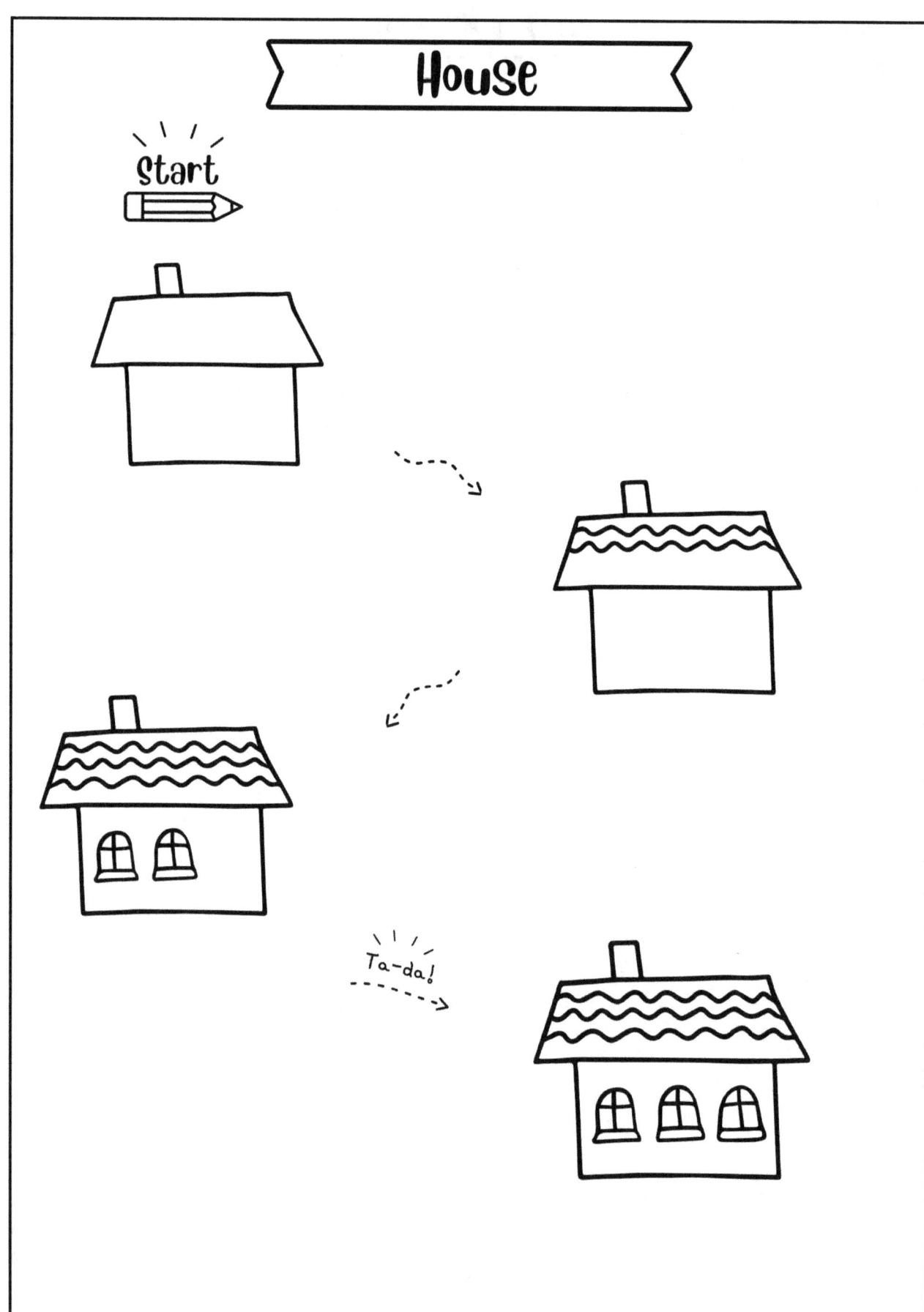

Your Drawing

Potion

Start

Ta-da!

Burger

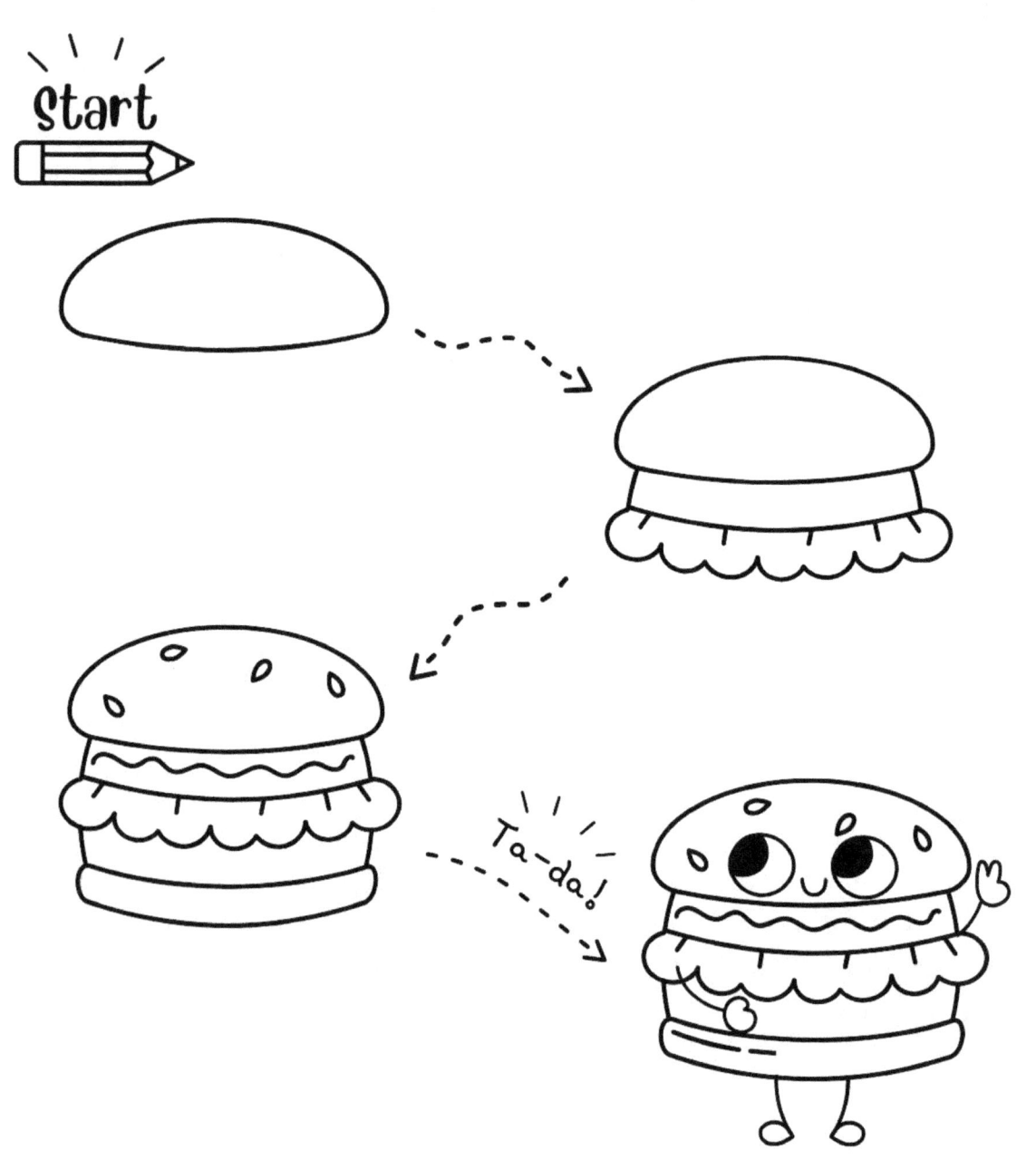

Record Player

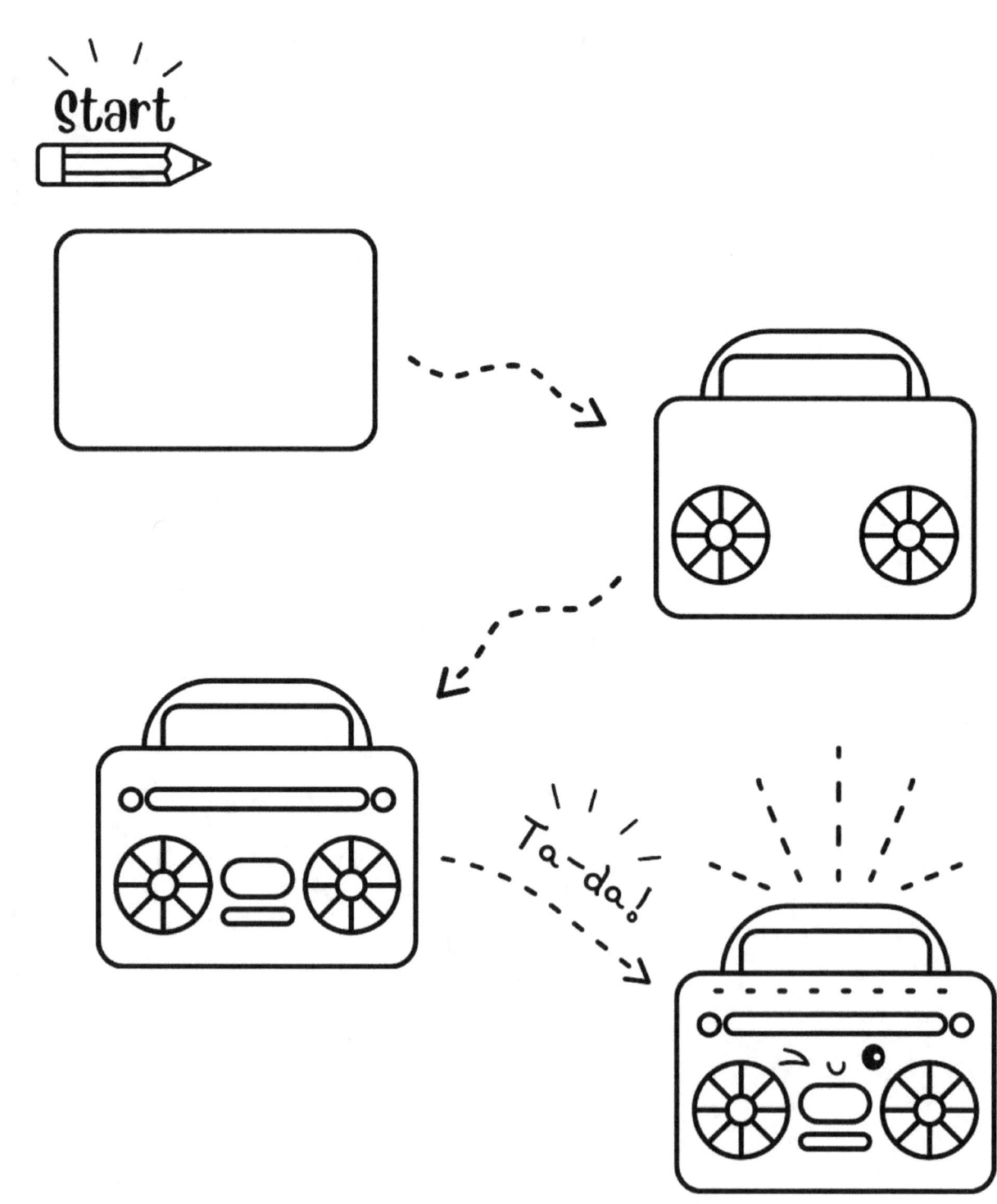

Ship

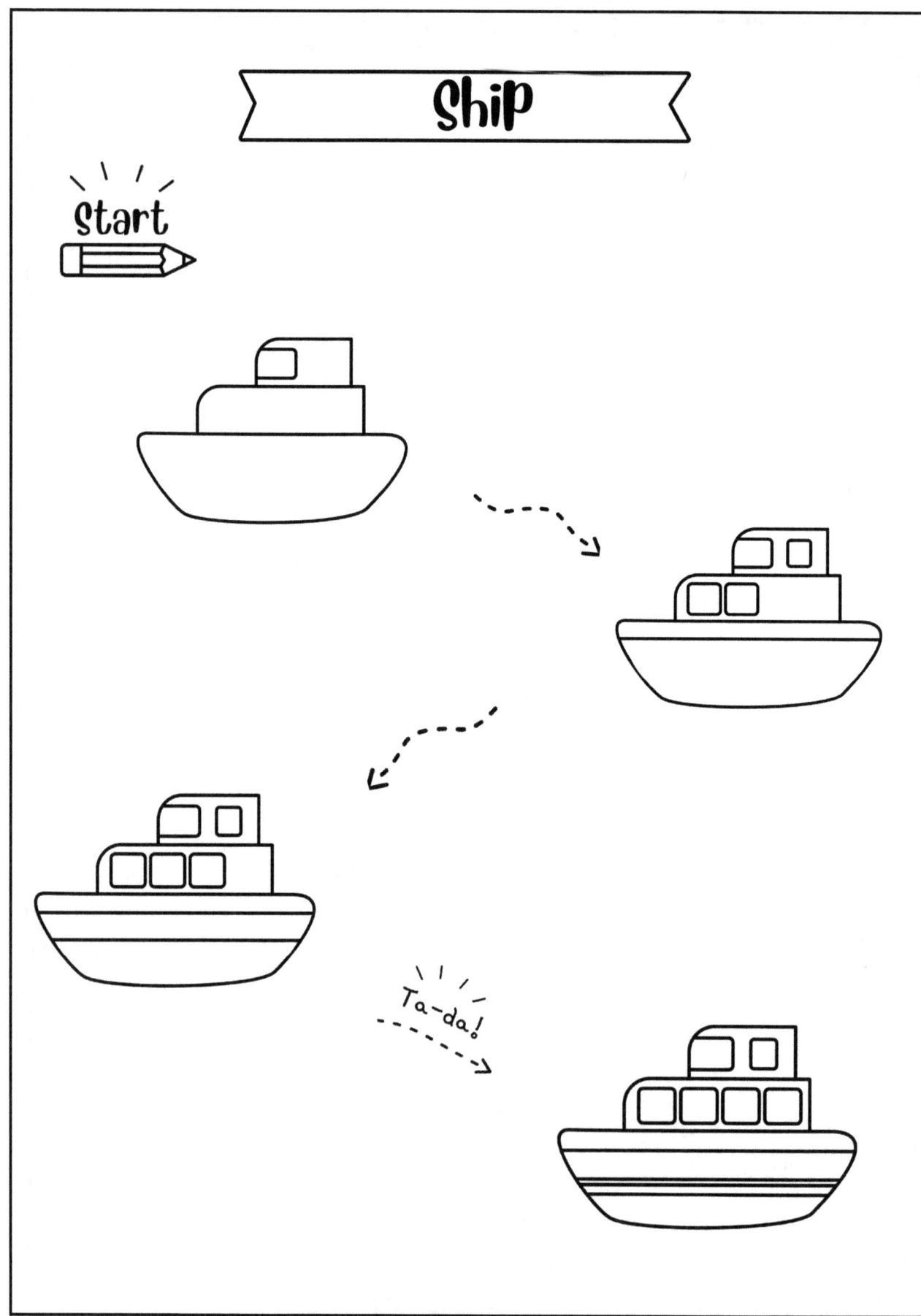

Your Drawing

Chicken

start

Ta-da!

Your Drawing

Car

Start

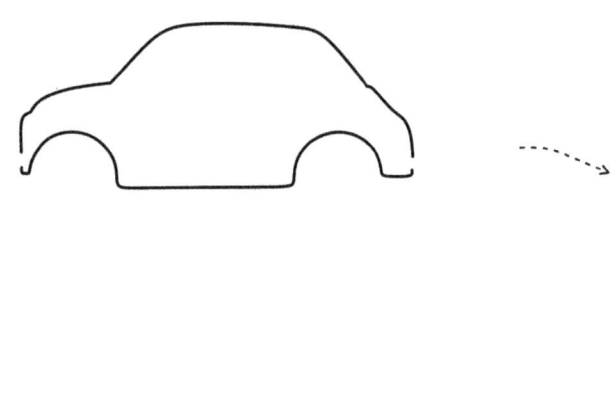

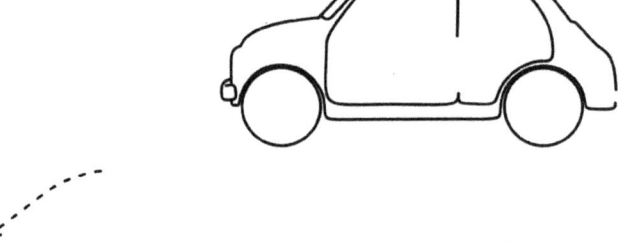

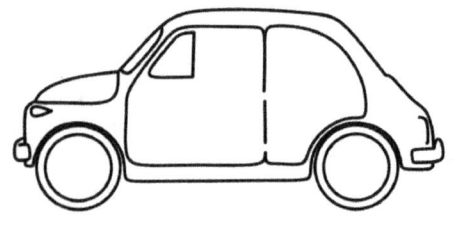

Ta-da!

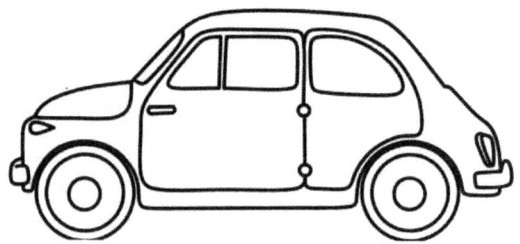

Your Drawing

Submarine

Start

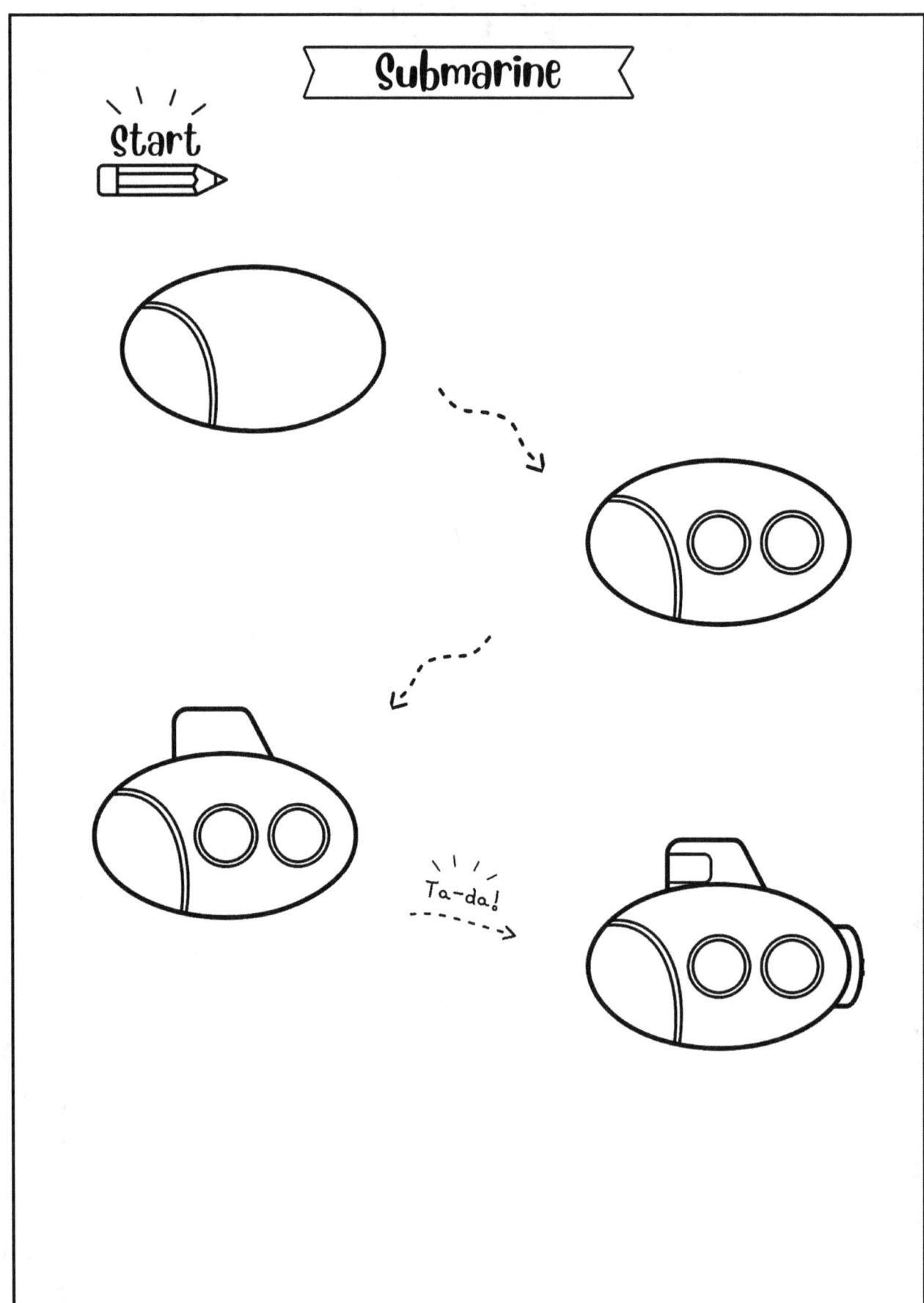

Ta-da!

Castle

Start

Ta-da!

Your Drawing

Rocket

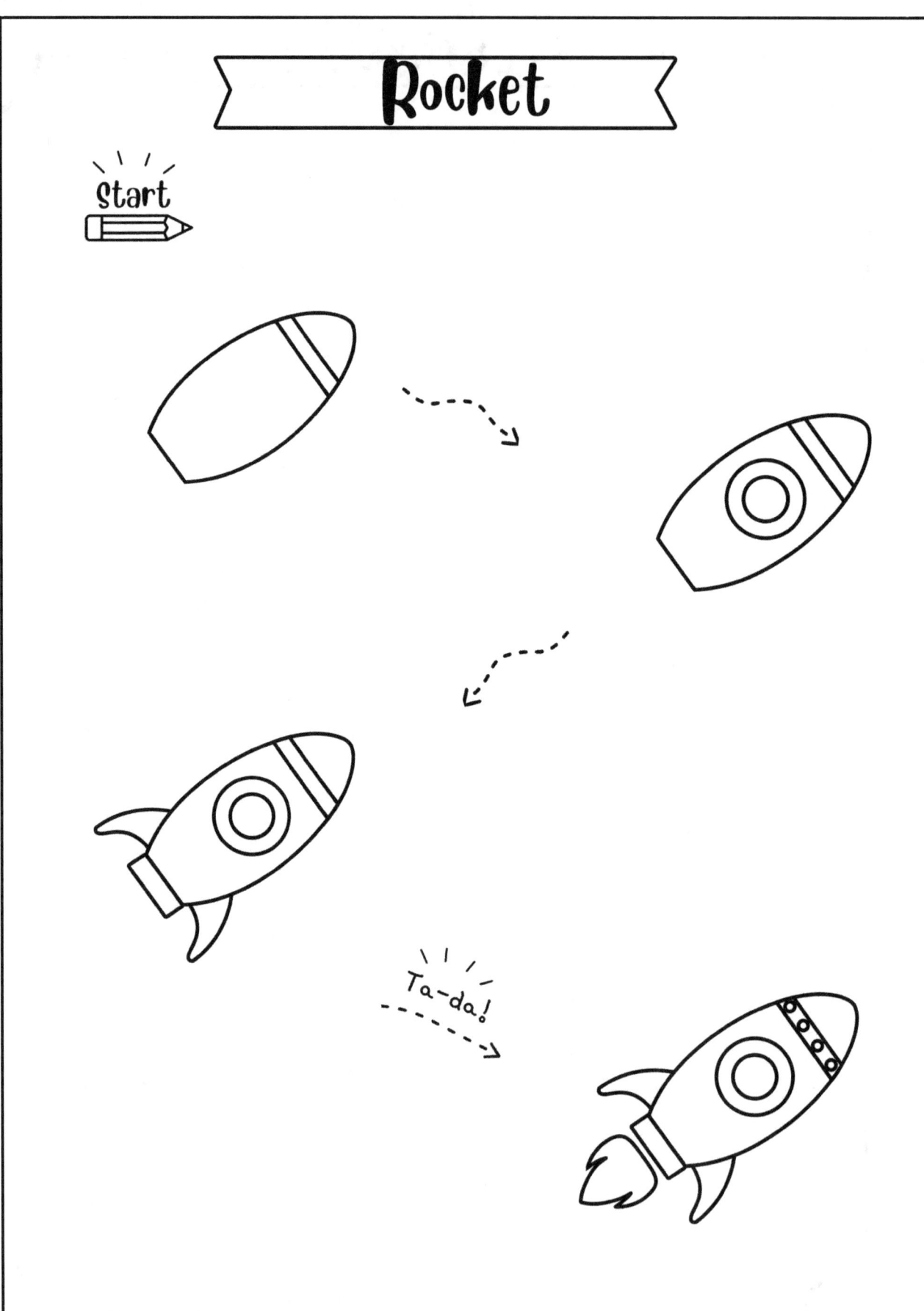

Cute Cherries

Start

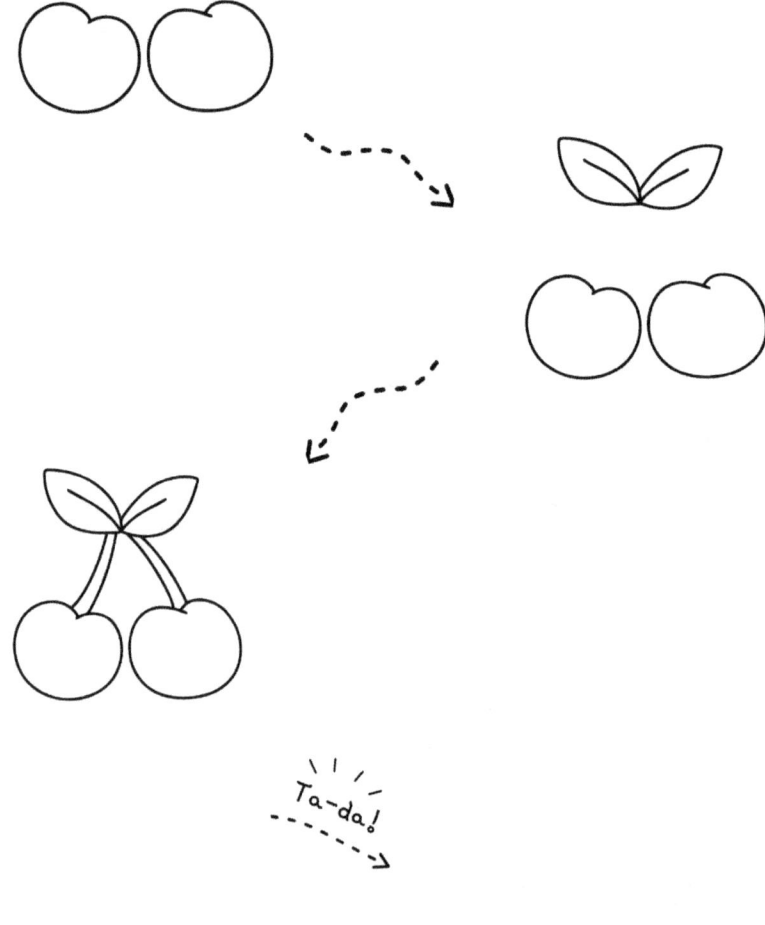

Ta-da!

Orange Tree

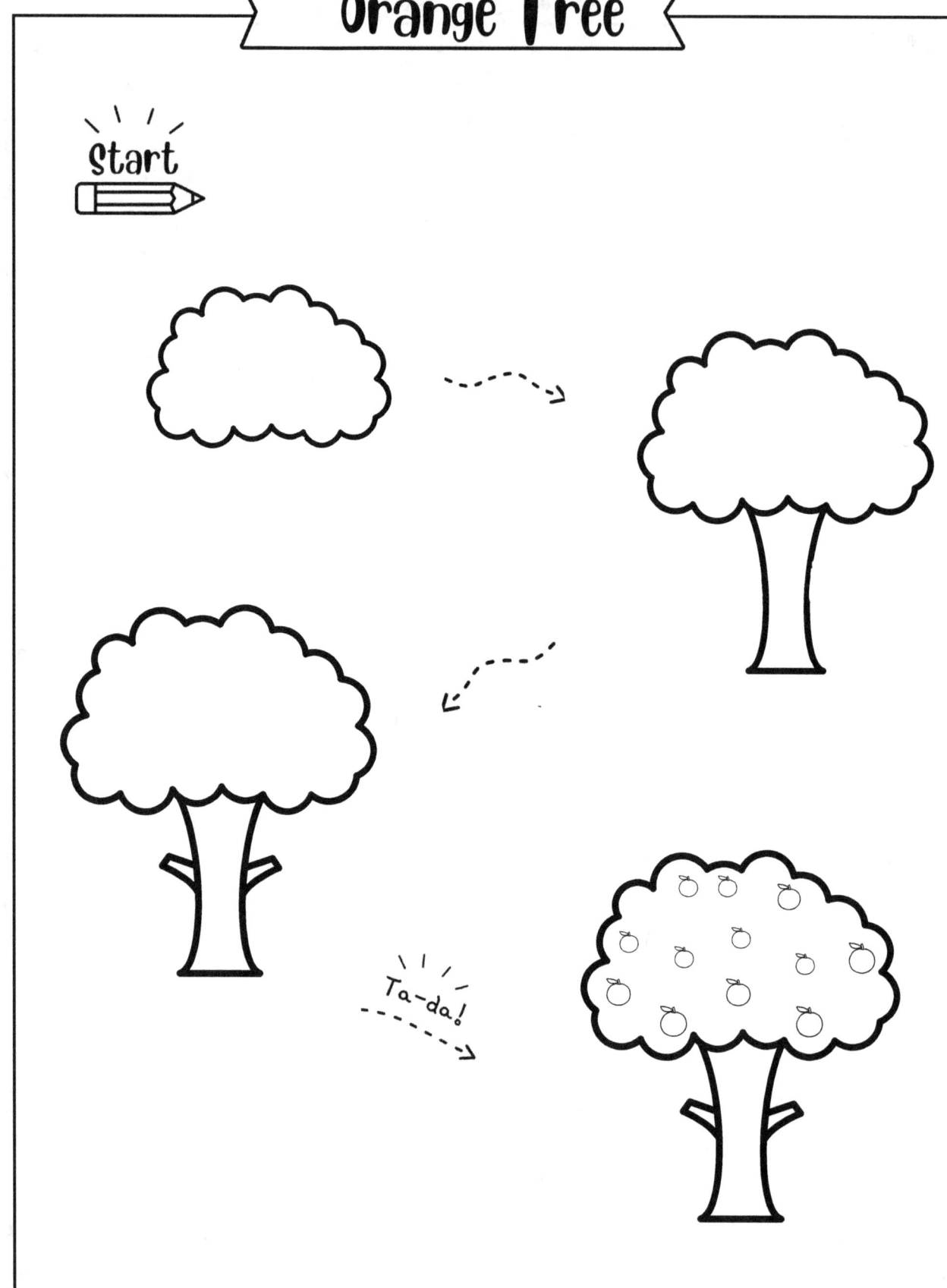

Well done!